THE BRITISH MUSEUM
DÜRER

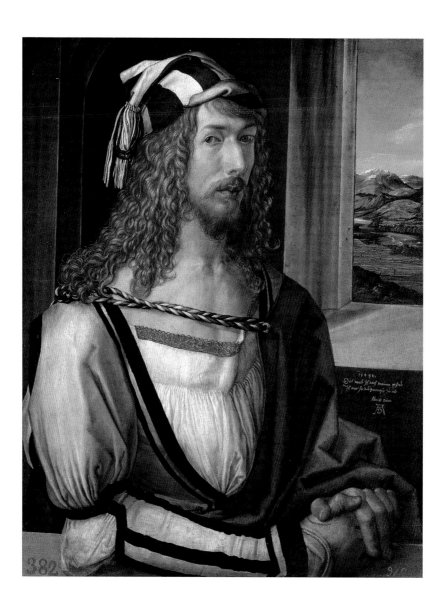

THE BRITISH MUSEUM
DÜRER

Giulia Bartrum

THE BRITISH MUSEUM PRESS

© 2007 The Trustees of the British Museum

Giulia Bartrum has asserted the right to be identified as the author of this work

First published in 2007 by The British Museum Press
A division of The British Museum Company Ltd
38 Russell Square, London WC1B 3QQ
britishmuseum.org/publishing

This edition published 2014

A catalogue record for this book is available from the British Library

ISBN 978-0-7141-2692-0

Photography by the British Museum Department of Photography and Imaging

Designed and typeset in Guardi by Caroline and Roger Hillier
The Old Chapel Graphic Design
www.theoldchapellivinghoe.com

Printed in China by 1010 Printing International Ltd

Frontispiece: *Self-portrait of Albrecht Dürer*, 1498
Oil on limewood, 520 × 410 mm

ALBRECHT DÜRER

(1471–1528)

Albrecht Dürer was a major artist of the northern Renaissance, and the first truly international artist to become a celebrity both during his own lifetime and since. His contemporaries compared him with the painters of antiquity Apelles and Phidias, and soon after his death he was described as 'the prince among German painters'. His achievements as a painter were matched by his remarkable exploitation of the traditional techniques of woodcut and engraving, which effectively altered the history of printmaking and ensured that his works were admired and collected throughout Europe. His 'AD' monogram became a widely recognized and respected trademark.

Dürer was born in 1471 in Nuremberg, at that time one of the largest and most prosperous cities in Europe, with a population of about 50,000, which lay at the centre of European trade routes and was famous for its international trade fairs. He was the son of a successful Hungarian goldsmith, Albrecht Dürer the Elder (1427–1502), and his earliest training was in his father's profession. The circumstances of his change of career are recorded in the artist's family chronicle, which he compiled late in life:

> When I could work neatly, my liking drew me more to painting than to goldsmiths' work. So I put it to my father. But he was troubled, for he regretted the time lost while I had been learning to be a goldsmith. Still he let me have my way, and in 1486, as one counts from the birth of Christ, on St Andrew's Day [30 November], my father bound me apprentice to Michael Wolgemut, to serve him three years long.

Dürer's godfather was Anton Koberger, the leading German publisher of his day. Koberger's best-selling *Nuremberg Chronicle* of 1494 contained illustrations designed by the painter Michael Wolgemut, with whom Dürer served his years of apprenticeship from 1486 to 1489. On the completion of his apprenticeship, Dürer undertook a period of travel in the upper Rhineland and Switzerland from 1490 to 1494 to widen his professional experience and make contacts that would help him in his future business.

On his return to Nuremberg in 1494, he married Agnes Frey, the daughter of a local metalwork designer, as he records in his family chronicle:

> And when I returned home, Hans Frey made a deal with my father and gave me his daughter, Miss Agnes by name, and with her he gave me 200 florins, and held the wedding – it was on Monday before Margaret's Day [7 July] in the year 1494.

Although the marriage was childless and certainly not satisfactory from a modern perspective, there is no reason to doubt that it fulfilled Dürer's expectations as the customary business arrangement which was expected of a man of his social standing at this date. During the autumn and winter of 1494–5, he visited northern Italy, a journey possibly stimulated by a severe outbreak of the plague in Nuremberg in September 1494. Dürer's main purpose lay in studying Italian art, which was a significant departure from the traditional training for fifteenth-century northern artists, and the work of Andrea Mantegna and Giovanni Bellini had a powerful effect on his artistic development. His journey through the Alps is recorded in a series of striking topographical watercolours, which not only indicate the route that he took, but are also of immense historical significance because they are the earliest pure landscape studies to have survived in the history of Western art.

Dürer opened his workshop in Nuremberg on his return from Italy in 1495. A significant aspect of trading in Nuremberg which assisted Dürer in his choice of occupation was that, unlike other major European cities, there had been no guilds there since the middle of the fourteenth century. Trades were regulated directly by the city council instead. Arts and crafts were divided into the 'sworn handicrafts', which included goldsmiths and metalworkers, and the 'free arts', which covered painting, printmaking and illuminating prints and manuscripts. This enabled the young Dürer to open a workshop selling primarily prints, which in other cities controlled by the guild system he would not have been able to do. Despite the fact that Dürer's paintings of the 1490s, particularly his self-portraits, show signs of his brilliant originality, he made a conscious decision to make a living chiefly from prints and, from the outset, determined on raising the artistic ambition of both woodcuts and engravings to a previously unimagined level. A number of factors assisted Dürer in this enterprise. He had access to the large pool of experienced block-cutters employed in the production of the *Nuremberg Chronicle* as well as to the advice of its publisher, his godfather Anton Koberger, whose typeface and translation he used for his innovative series of *Apocalypse* woodcuts of 1498. In 1495 he probably first made acquaintance with the man who became his closest friend, the classical scholar Willibald Pirckheimer (1470–1530). Pirckheimer introduced him to a circle of humanists who informed him of the literature and ideals of the Italian Renaissance and advised on innovative subjects that would appeal to the educated elite.

From 1505 to 1507 Dürer visited Italy again, spending most of his time in Venice, the wealthiest city in Europe, where there was a large and prosperous German community. He was commissioned by the German merchants to paint the *Feast of the Rose Garlands* for the church of San Bartolommeo (now in the National Gallery, Prague). The success of this commission, as well as many details of his life in

Italy, is recorded in the remarkable survival of a series of letters written by Dürer to his friend Pirckheimer at home in Nuremberg. His comment 'Here I am a gentleman, at home only a parasite' emphasizes the rise of his status brought about by success and financial reward and, consequently, the importance of taking on well-paid commissions for elaborate painted works as they raised his reputation as an artist.

From 1507 to 1512 Dürer worked on commissions for numerous paintings, as well as his famous religious series of prints for the open market. The woodcut series of the *Life of the Virgin*, the *Great Passion* and the *Little Passion* were published in 1511. Signs of his increased social standing and prosperity were evident by 1509, when he became a member of the Great Council of Nuremberg, and purchased a large house in the Zisselgasse (today the Dürer-Haus Museum).

Dürer's achievements as a printmaker played a key role in the choice of the woodcut medium by the Holy Roman Emperor Maximilian I (1459–1519) for his colossal commemorative projects commissioned in Augsburg. Dürer was the chief designer of Maximilian's *Triumphal Arch* of 1515–17. His imperial annuity was ratified after Maximilian's death by the Emperor Charles V in Cologne in 1520. Dürer's fame had circulated widely around Europe by the time he travelled to the Netherlands in 1520–1. A detailed account of his activities there has survived in a transcription of his diary, and shows that he was fêted by all he met in a manner akin to a contemporary show-business personality.

In his later years, Dürer produced engraved portraits of his friends and associates and in 1526 presented to Nuremberg city council his final painting, *The Four Holy Men* (Munich, Alte Pinakothek). He devoted most of his energy to publishing his theoretical ideas on proportion, *Instructions on Measurement* in 1525 and *Four Books of Human Proportion* posthumously in 1528, as well as

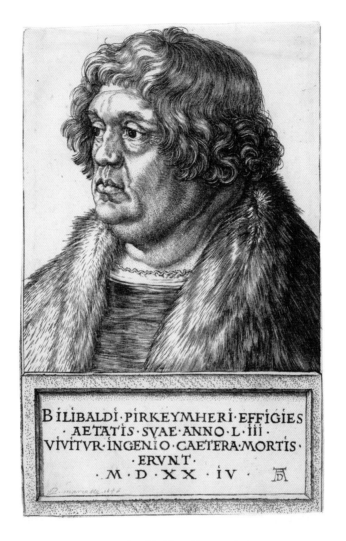

Portrait of Willibald Pirckheimer, 1524.
Engraving, 180 × 113 mm

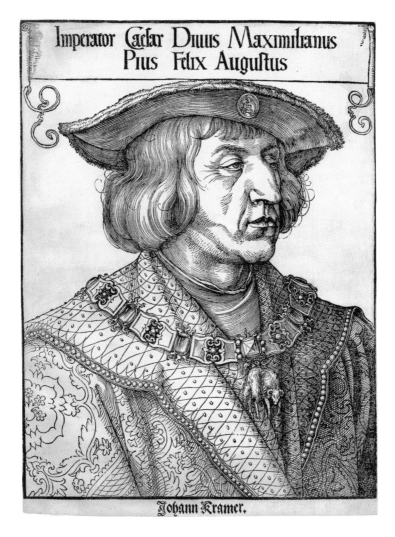

Portrait of Emperor Maximilian I, c.1518.
Woodcut, 445 × 328 mm

a *Treatise on Fortification* in 1527. By this date, his health had become weakened by recurring bouts of a feverish illness, which he had first contracted while he was in the Netherlands and which may have been malaria; the specific cause of his death on 6 April 1528 is unrecorded. He left no will, and his estate, which was valued at 6,874 florins at the time of his death – qualifying him as one of the wealthier citizens of Nuremberg – was inherited entirely by Agnes, who continued to live in the house in Zisselgasse until her own death in 1539.

Dürer was a prolific draughtsman and approximately 970 drawings by him are known to have survived. The collection of 138 drawings in the British Museum is one of the finest in existence and includes examples from all stages of his career. Dürer's prints have been highly prized since his lifetime and remain at the core of all serious print collections. The British Museum has a virtually complete collection of Dürer's 99 engravings, 6 etchings and a substantial number of his designs for 346 woodcuts and book illustrations.

This book illustrates a selection of Dürer's best-known works in the British Museum. It aims to examine his working methods and show his versatility and spontaneity as a draughtsman. The development of his ideas from drawing to elaborate printed composition is revealed by comparisons of drawings with related woodcuts or engravings.

1 SEATED VIRGIN AND CHILD

This drawing was made by Dürer as a young man during a period of travel that he undertook after finishing his apprenticeship. It reflects the influence of Martin Schongauer (c.1440/53–91), the most important German painter of the generation preceding Dürer's, whose small religious paintings and engravings were much admired. Dürer travelled to Schongauer's workshop in Colmar in 1492 hoping to meet him, but the elder artist had died several months before.

Seated Virgin and Child
c.1491–2
Pen and brown ink
205 × 197 mm

8.3

13

2 VIRGIN AND CHILD WITH A GRASSHOPPER

This is one of the earliest prints that Dürer produced when he opened his workshop in Nuremberg in 1495. Its composition and particularly the heavy angular drapery and the tender expression of the Virgin and Child are closely associated with his drawing of the *Seated Virgin and Child* (no. 1). The insect in the right foreground, traditionally described as a dragonfly, is in fact an accurate depiction of a grasshopper and shows Dürer's interest in the natural world.

Virgin and Child with a Grasshopper
*c.*1495
Engraving
236 × 185 mm

3 MAN ON HORSEBACK

Dürer made drawings and prints of horses at all stages of his career. This lively drawing shows a rider returning from a hunt, the success of which is indicated by the sprigs of oak on the horse's tail and forelock. Dürer's interest in depicting energy and movement is shown in the rider, who rises out of the saddle, and in the horse's legs, which have been reworked in places.

Man on Horseback
c.1490–4
Pen and brown ink
201 × 189 mm

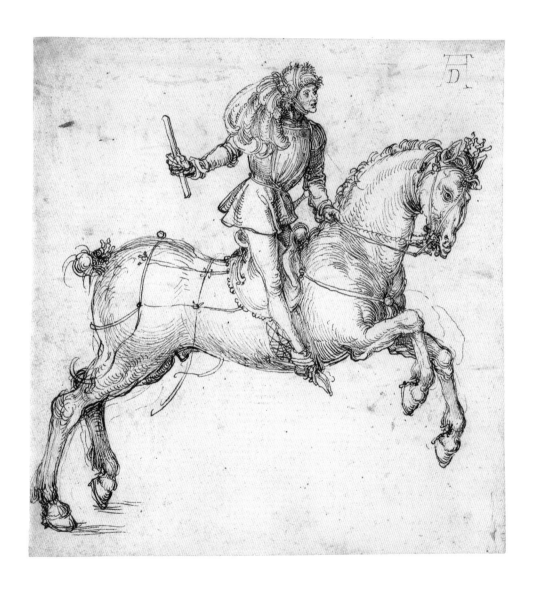

17

4 THE SMALL COURIER

Dürer later referred to a drawing such as *Man on Horseback* (no. 3) for this small engraving of a rider, in which a fashionably attired horseman is set in a carefully composed landscape to give the impression of galloping down a road. The precise subject of the print is not clear; its title was given by the Austrian scholar Adam Bartsch (1757–1821), who published the first comprehensive catalogue of Dürer's prints in 1808.

The Small Courier
c.1496
Engraving
108 × 77 mm

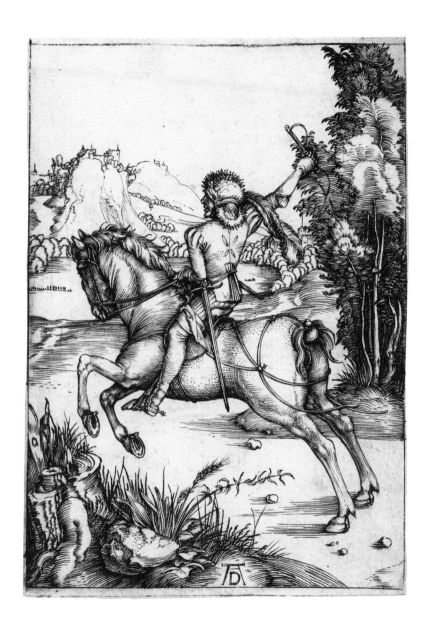

5 YOUTH KNEELING BEFORE AN EXECUTIONER

Dürer's use of cross-hatching and line is still very close to the drawing method of Martin Schongauer in this early drawing, but the bold attempt to convey the texture of the skin and muscle of a semi-nude figure sets him apart from earlier artists. The subject has not been identified.

Youth Kneeling before an Executioner
c.1493
Pen and black ink
253 × 164 mm

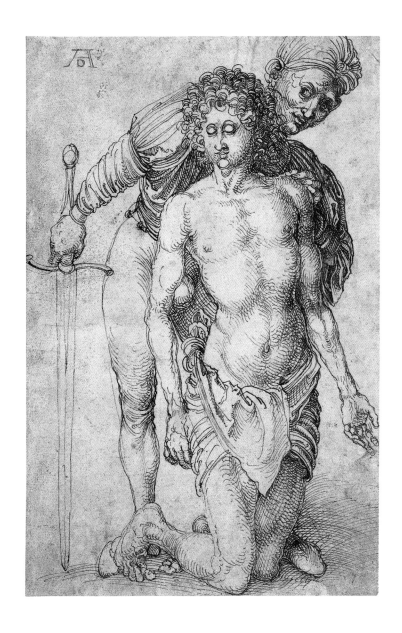

This woodcut comes from one of Dürer's famous series of religious prints, the *Large Passion*, which contains twelve woodcuts, seven of which he made between 1497 and 1500. He produced four additional prints to complete the series in 1510 and then published it in book form with a title-page (see no. 26) and text in 1511. His compositions for the prints became increasingly sophisticated as the series progressed, and it is especially noted for its variety of figures. In this, the sixth print of the series, Dürer has used a similar figure to the executioner in no. 5 for the man standing behind Christ on the far left.

Christ Shown to the People
from the *Large Passion* series
c.1497–1500
Woodcut
392 × 284 mm

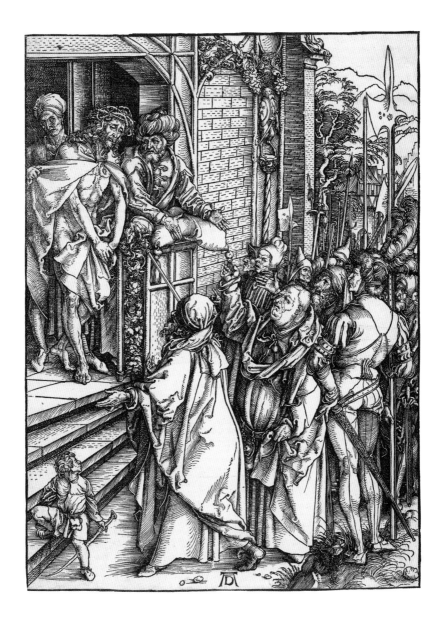

7 STUDY FOR THE PRODIGAL SON

8 THE PRODIGAL SON

Dürer's meticulous approach to the design of his prints reveals itself in this preparatory study for the *Prodigal Son*, which is the earliest compositional study for a print to have survived. It is drawn in the reverse sense, the direction he would have engraved the plate. An early drawn copy of this sheet (Nuremberg, Germanisches Nationalmuseum) shows that originally it was about the same size as the print, but was later cut along the upper and lower edges. The print shows that Dürer was not satisfied with the space surrounding the main figure because he has moved the houses further forward and introduced piglets to fill the foreground. The subject of the prodigal son kneeling in a muddy farmyard was entirely new and exemplifies Dürer's original approach to printmaking.

Study for the Prodigal Son
c.1495–6
Pen and black ink
216 × 220 mm

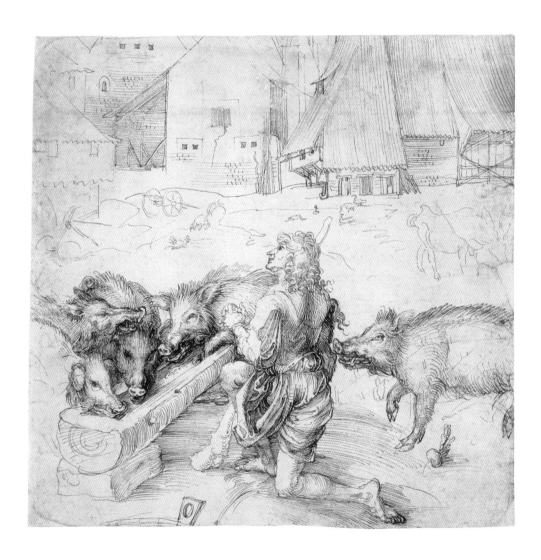

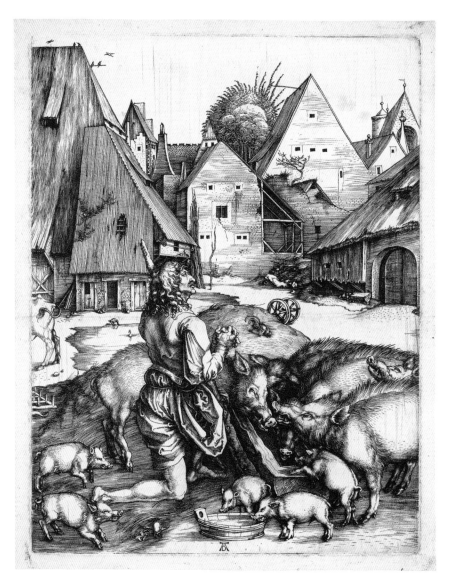

*The Prodigal Son, c.*1496
Engraving, 261 × 206 mm

9 STUDY OF A ROCK-FACE IN A QUARRY NEAR
 NUREMBERG

10 LANDSCAPE WITH A WOODLAND POOL

11 ST JEROME IN PENITENCE

12 ST JEROME IN A LANDSCAPE

Dürer's landscape watercolours are the earliest pure landscape studies to have survived in the history of Western art. They were made during his journey across the Alps when he travelled to Italy in 1495–6 and in the countryside around Nuremberg on his return. They were not made with particular compositions in mind, but together formed a stock of material to which Dürer referred when he designed background detail in his prints and paintings. The colours and textures conveyed in these watercolours are reflected in the painting and engraving of St Jerome praying in a landscape, which Dürer produced during the second half of the 1490s.

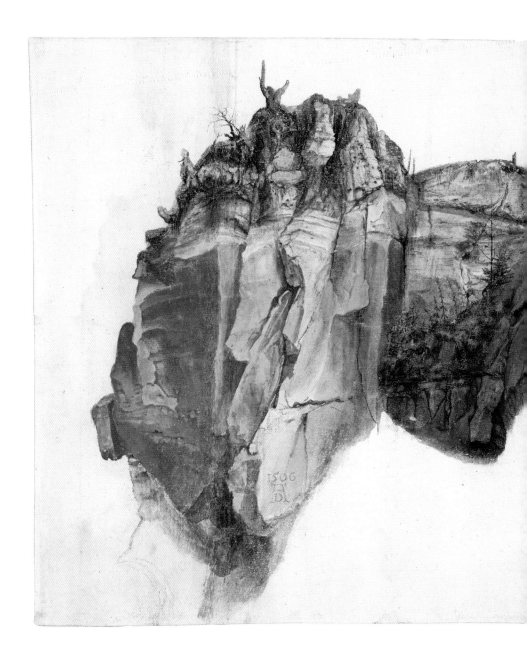

Study of a Rock-Face in a Quarry near Nuremberg
c.1495–6
Watercolour and bodycolour over black chalk
225 × 287 mm

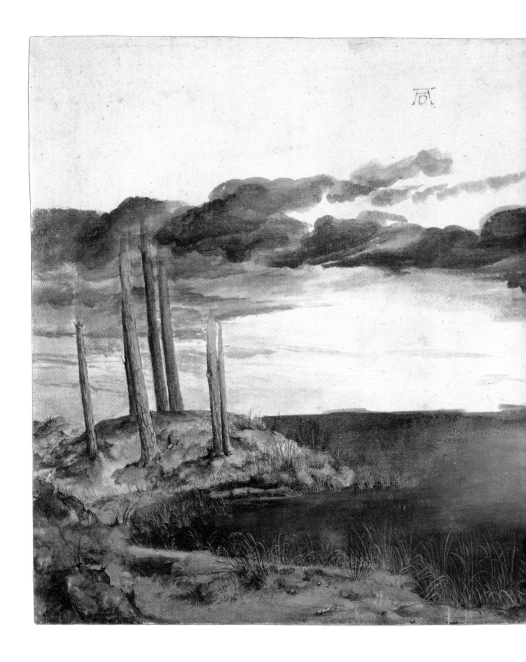

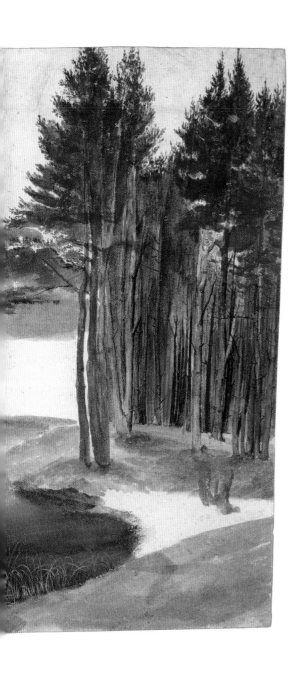

Landscape with a Woodland Pool
*c.*1496
Watercolour and bodycolour
262 × 365 mm

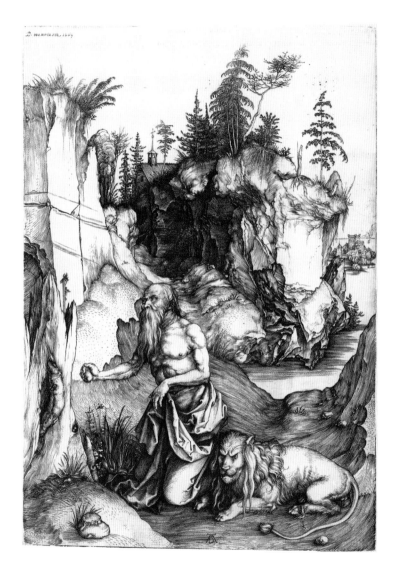

St Jerome in Penitence, c.1496
Engraving, 320 × 223 mm

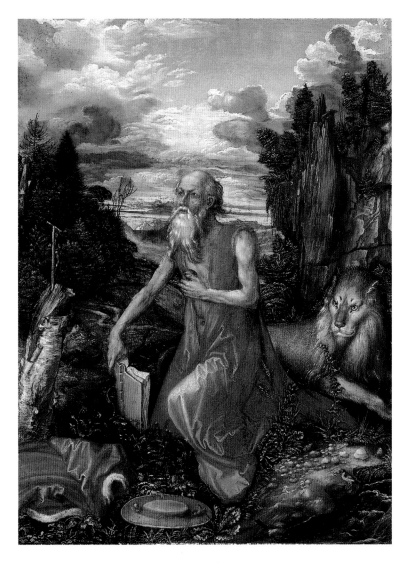

St Jerome in a Landscape, c.1497
Oil on pearwood, 231 × 174 mm

This watercolour is entitled *weier haws* ('pond house') by the artist. It was made at about the same time as his *Landscape with a Woodland Pool* (no. 10), soon after he returned from his first visit to Italy. The building has been identified from a local map of about 1595 as the *Weyerhäusslein* (small house on a pond) at St Johannis, which in Dürer's day was just outside the city walls but is now a suburb of Nuremberg.

Fisherman's House on a Lake near Nuremberg
*c.*1496
Watercolour and bodycolour
213 × 225 mm

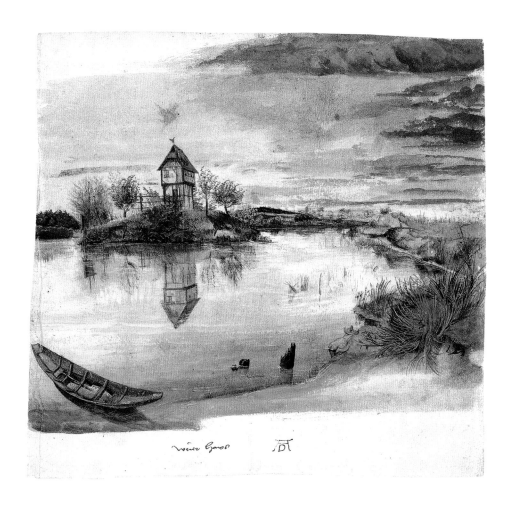

14 VIRGIN AND CHILD WITH A MONKEY

Dürer's watercolour *Fisherman's House on a Lake near Nuremberg* (no. 13) reappears in reverse in his famous print of the *Virgin and Child with a Monkey*, where the calm, classical pose of the figures and the exotic creature contrast curiously with the windswept bushes and the distinctly northern building. This engraving was one of the most popular of Dürer's works during the sixteenth century. Its success was due to the mixture of Italian Renaissance forms with northern landscape elements, combined with Dürer's virtuoso engraving technique. His superlative skill at distinguishing a range of textures with the engraver's burin was unprecedented.

Virgin and Child with a Monkey
c.1498
Engraving
191 × 123 mm

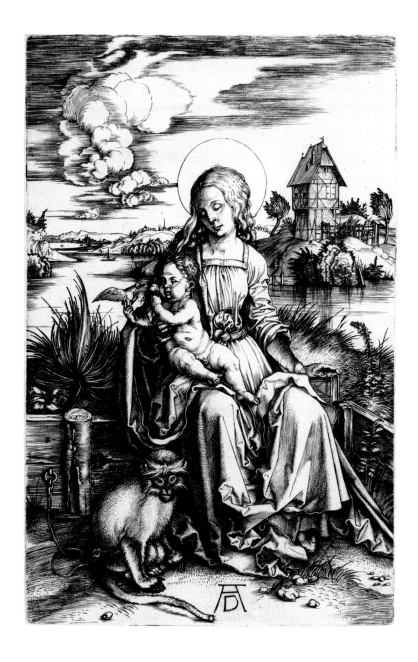

15 THE VISITATION

Dürer made seventeen of the woodcuts for his *Life of the Virgin* series between 1503 and 1505 before his second journey to Italy, and a final two in 1510 before he published the series as a book with a frontispiece and a Latin text in 1511, at the same time as the *Large Passion* and a second edition of the *Apocalypse*. The series was particularly popular for its variety of architectural and landscape backgrounds.

The Visitation
from the *Life of the Virgin* series
c.1503–5
Woodcut
299 × 210 mm

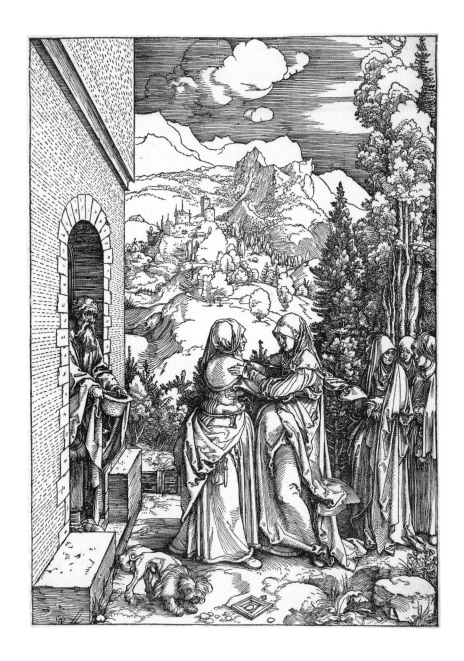

This striking study of a tree is one of Dürer's finest watercolours. His landscape watercolours of alpine views and studies of trees made in the 1490s frequently reappeared in the background settings of his prints and paintings. Trees similar to this one are seen in the background of his painting the *Feast of the Rose Garlands* of 1506 (Prague, National Gallery) and in his woodcut *The Visitation* (no. 15).

A Spruce Tree
c.1495–6
Bodycolour and watercolour
293 × 144 mm

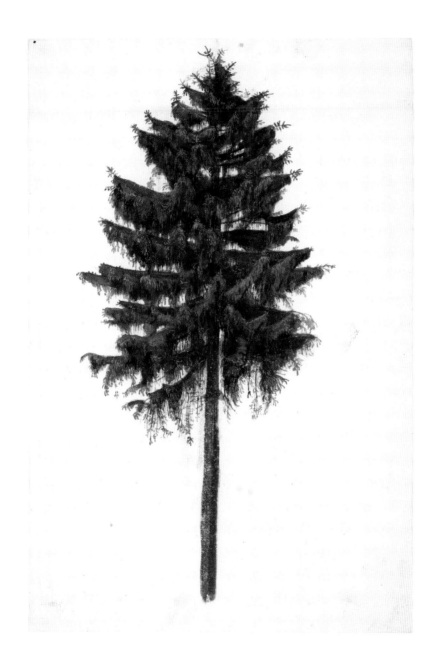

17 NEMESIS or LARGE FORTUNE

This print is sometimes called the *Large Fortune* to distinguish it from Dürer's small engraving *Fortune*, which he made in the 1490s. Dürer himself referred to it as *Die Nemesis* in his Netherlands diary of 1521. Nemesis was the classical goddess of retribution whose goblet and bridle represent reward and castigation. Dürer's combination of Nemesis with the traditional winged figure of Fortune standing on a globe created an entirely new image. The beautifully detailed landscape beneath is a view of Chiusa in the southern Tyrol (Alto Adige) and is probably based on a watercolour which has not survived.

Nemesis or *Large Fortune*
c.1501–2
Engraving
333 × 229 mm

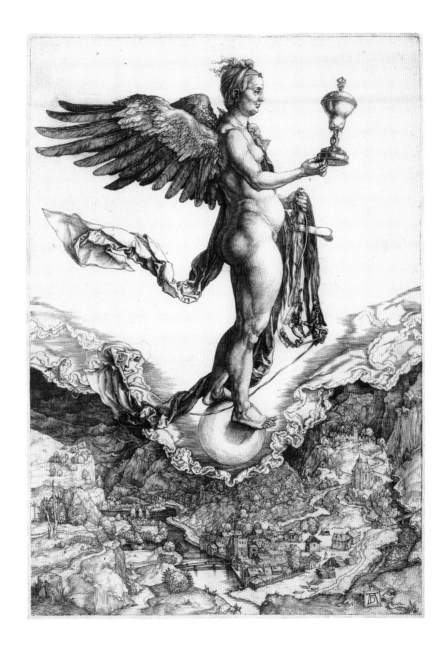

43

18 DESIGN FOR THE FIGURE OF FORTUNE
AND A STUDY OF A BIRD'S WING

Dürer's study for the figure of *Large Fortune* was made in preparation for the print (no. 17). It demonstrates his interest in proportion, a subject which preoccupied him for much of his career. In a draft for the introduction to his *Four Books on Human Proportion* (1528), Dürer wrote that his interest in the subject was stimulated by meeting the artist Jacopo de' Barbari (*c*.1460–1516) in Nuremberg in 1500:

> I found no one who [knows or] has written about a system of human proportion, except Jacobus, a native of Venice and a lovely painter. He showed me how to construct man and woman based on measurements. When he [first] told of this, I would rather have come into possession of his knowledge than of a kingdom. . . . But Jacobus I noticed did not wish to give me a clear explanation; so I went ahead on my own and read Vitruvius, who describes the proportions of the human body to some extent.

The lines incised with a stylus on the sheet show that Dürer has constructed this figure according to the Vitruvian system of forming a body from eight head-lengths. The drawing also shows that he originally planned smaller wings for the figure. The separate study of the wing on the left is closer to those that appear in the engraving.

Design for the Figure of Fortune and a Study of a Bird's Wing
c.1501–2
Pen and brown and black ink over lines incised with a stylus
257 × 206 mm

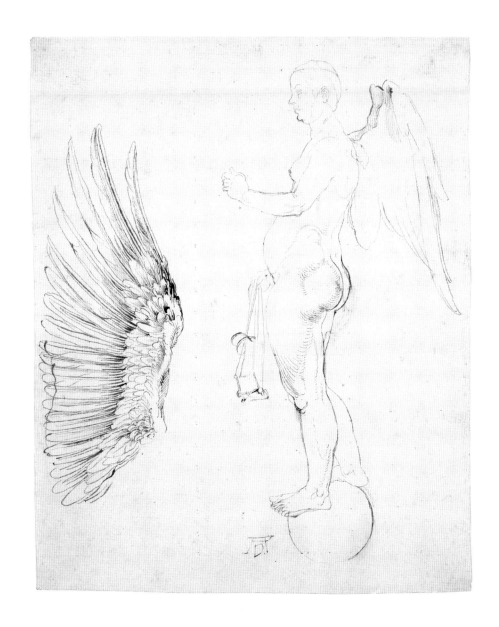

19 LADY OF NUREMBERG DRESSED FOR CHURCH

Dürer's interest in fashion is an inherent part of his art, and is especially notable in his portraits. He inscribed this costume study 'A woman of Nuremberg dressed to go to church'. It is one of a group of detailed drawings that he made of elegantly dressed ladies of Nuremberg, perhaps for a series of prints that was never executed. The distinctive headdress is known as a *Stürz* and was made of starched linen supported on a frame.

Lady of Nuremberg Dressed for Church
1500
Brush and watercolour
316 × 171 mm

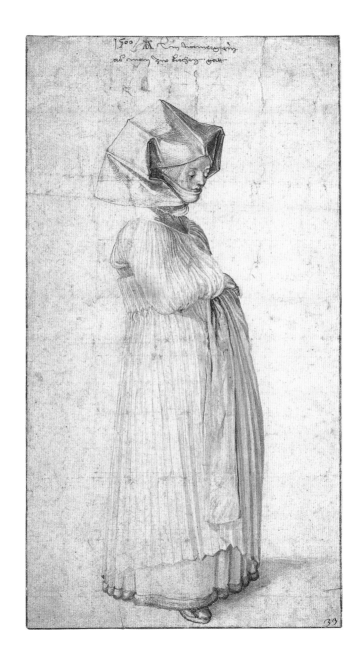

Dürer's seies of woodcuts of the *Life of the Virgin* was particularly popular with his contemporaries for its range of figure types and gestures. The elegant figure represented in *Lady of Nuremberg Dressed for Church* (no. 19), which he drew some three years earlier, is seen here in the right foreground as a bystander to the marriage of the Virgin.

The Marriage of the Virgin
from the *Life of the Virgin* series
*c.*1503–5
Woodcut
295 × 207 mm

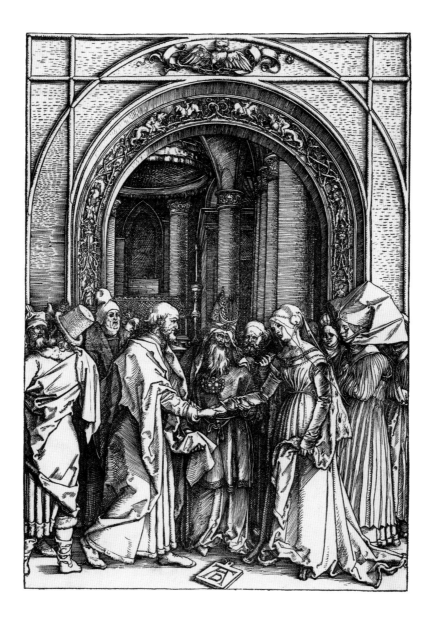

21 ADAM AND EVE

22 STUDIES FOR THE HAND AND ARM OF ADAM, AND ROCKS AND BUSHES

23 STUDY FOR THE FIGURE OF EVE

24 STUDIES OF HARES

Dürer's pride in his print of *Adam and Eve* is displayed in the longest, most prominent inscription he ever made on an engraving: 'Albrecht Dürer of Nuremberg made this 1504'. It represents the culmination of his study of classical proportion, and the figures are based on Roman sculptures of Apollo and Venus. It also displays his virtuoso mastery of the engraving technique. The large number of surviving preparatory drawings for the figures documents the particular care with which he planned the design. In the pen-and-ink drawing, Dürer has experimented with various positions for Adam's arms and hands, drawn in reverse, of which some are shown holding the apple offered by Eve. His *Study of Eve* shows how he has developed the fall of light and shade on the figure. Like his other drawings of animals, the *Studies of Hares* were not made with the print in mind, but drawn directly from nature at an earlier stage. The hare on the right of the sheet is seen in the print next to Eve's leg.

Adam and Eve
1504
Engraving
255 × 196 mm

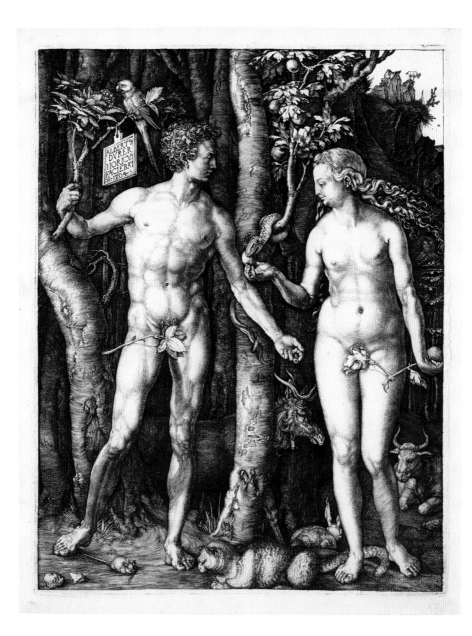

51

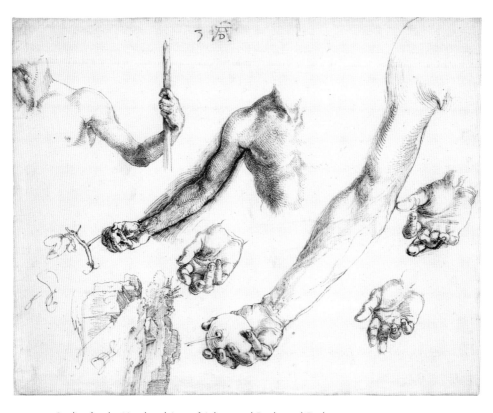

Studies for the Hand and Arm of Adam, and Rocks and Bushes
1504
Pen and brown and black ink
216 × 275 mm

Study for the Figure of Eve
1504
Pen and brown ink, with brown wash
277 × 171 mm

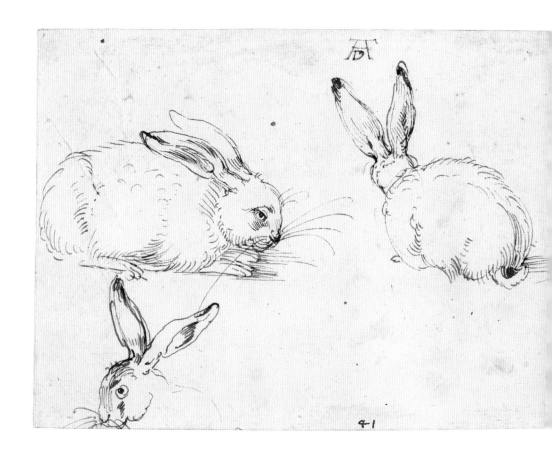

Studies of Hares
c.1501–4
Pen and black ink
126 × 220 mm

The medium of charcoal is particularly suited to the expression of suffering that Dürer has conveyed so powerfully in this drawing. His inscription on it, 'I produced these two countenances when I was ill', links it with a charcoal drawing of the head of a suffering man, also in the British Museum. Both are thought to have been drawn during an epidemic which broke out in Germany in 1503.

Head of the Dead Christ
1503
Charcoal
310 × 221 mm

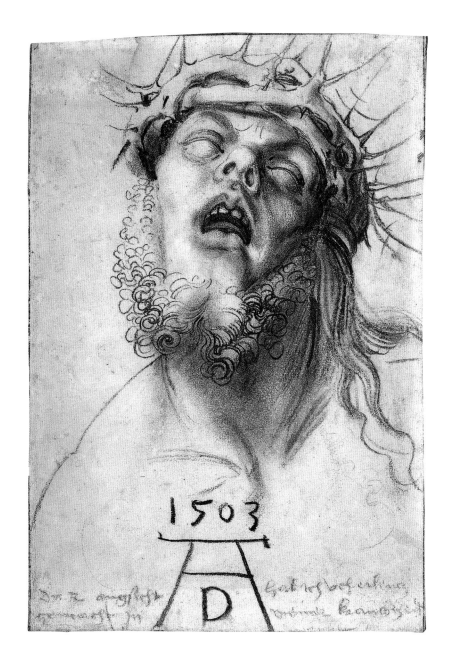

26 CHRIST AS THE MAN OF SORROWS MOCKED BY A SOLDIER

Dürer was preoccupied for most of his working life with the subject of the Passion, the story of Christ's last days on earth from shortly before his arrest to his death and resurrection. He designed at least six different printed and drawn series of the subject, and many related works. Studies such as *Head of the Dead Christ* (no. 25) underlie his expression of human pain and emotion in many of the prints, but especially those in the *Large Passion*.

Christ as the Man of Sorrows Mocked by a Soldier
title-page to the *Large Passion* series
1511
Woodcut
330 × 193 mm

Passio domini nostri Jesu. ex hierony-
mo Paduano. Dominico Mancino. Sedulio. et Bapti-
sta Mantuano. per fratrem Chelidonium colle-
cta. cum figuris Alberti Dureri
Norici Pictoris.

Has ego crudeles homo pro te perfero plagas

Atq; meo morbos sanguine curo tuos.

Vulneribusq; meis tua vulnera, morteq; mortem

Tollo deus:pro te plasmate factus homo.

Tuq; ingrate mihi:pungis mea stigmata culpis

Sæpe tuis.noxa vapulo sæpe tua.

Sat fuerit.me tanta olim tormenta sub hoste

Iudæo passum:nunc sit amice quies.

This drawn study for the *Good Thief* is taken from a studio model. It was sketched rapidly from life, and then more clearly defined with stronger pen strokes and cross-hatching. The cross was drawn last. It does not specifically relate to any of Dürer's prints, but was of particular influence to his workshop assistants in the design of paintings and prints of scenes of the Crucifixion.

Study for the Good Thief
c.1503–5
Pen and brown ink
268 × 127 mm

61

28 CRUCIFIXION

Three series of Dürer's prints relate the story of the arrest, torture and death of Christ: the *Large Passion* and the *Small Passion*, which were both published as books in 1511, and the *Engraved Passion*, a series of engravings which he produced between 1507 and 1512. The small, beautifully engraved *Crucifixion* was the latest print Dürer made of the subject.

Crucifixion
from the *Engraved Passion* series
1511
Engraving
118 × 75 mm

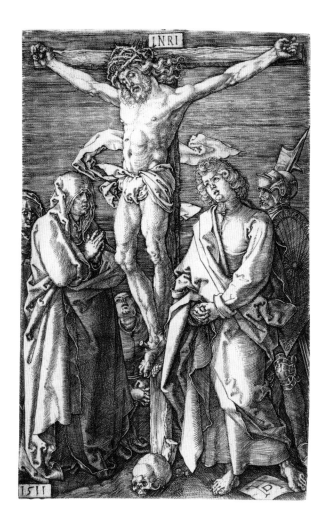

29 ST JEROME IN HIS STUDY

30 KNIGHT, DEATH AND THE DEVIL

31 STUDIES OF THREE CARICATURE HEADS, DRAPERY AND A DOG

St Jerome in his Study, *Knight, Death and the Devil* and *Melancholia* (no. 32) are known as Dürer's 'master engravings' and are the three most important engravings he ever produced. They are comparable in size and technical sophistication, but strikingly different in subject. The warm sunlit interior depicted in *St Jerome* is famous for its evocative atmosphere and elaborate detail. It personifies the life of contemplation, as opposed to *Knight, Death and the Devil*, which portrays a man of action. Dürer referred to this commanding image of a horse simply as *Reuter* (Rider), but the presence of the other figures suggests a more enigmatic subject. Many have seen the knight as a symbolic depiction of human and Christian fortitude, about which Erasmus of Rotterdam, the famous Dutch scholar and contemporary of Dürer, had published a book, *Handbook of the Christian Knight*, in 1502.

The figure of a dog in no. 31 is a detailed study made directly in preparation for *Knight, Death and the Devil*, drawn in the direction that Dürer would have engraved the plate. The drawing was only known from an etched reproduction of it made in the late eighteenth century, until it was identified in 1960 when a member of the public showed it to staff at the British Museum.

St Jerome in his Study
1514

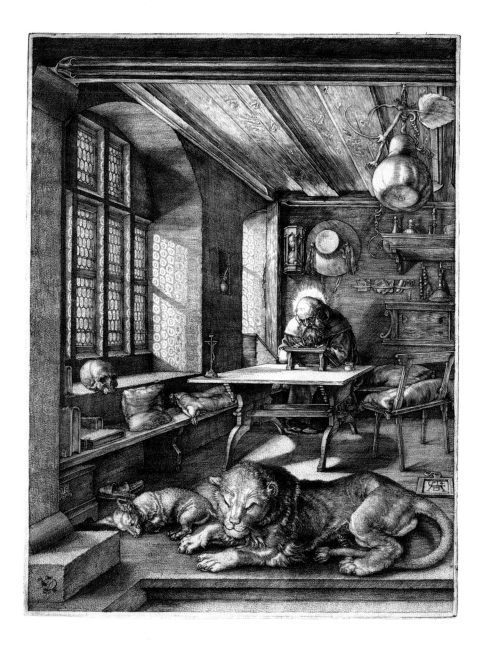

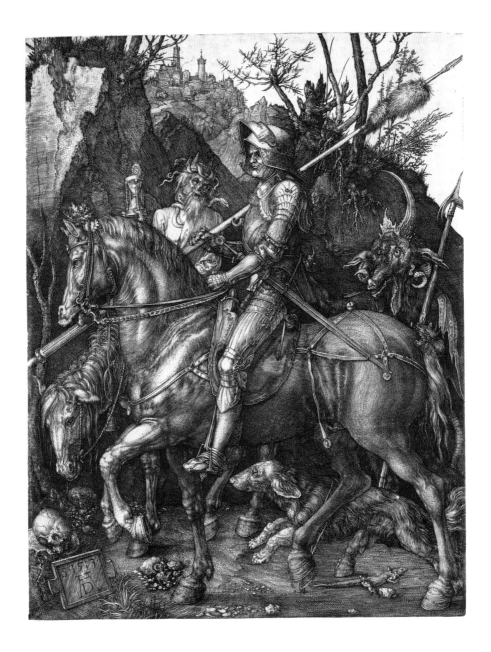

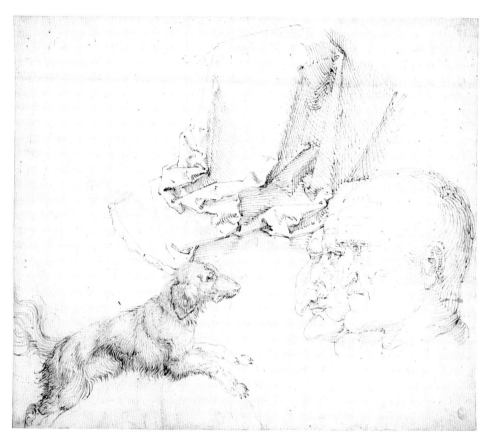

Studies of Three Caricature Heads,
Drapery and a Dog
1513
Pen and brown ink
181 × 209 mm

Knight, Death and the Devil
1513
Engraving
246 × 190 mm

Dürer's complex allegory of melancholy is one of the most discussed images in Western art. Its mood of weary despair expressed by the heavily draped winged woman, and the clutter of instruments that surround her are beautifully emphasized by the variety of surfaces and textures conveyed through Dürer's total mastery of the burin, the engraver's tool. Dürer never attempted to achieve this level of technical sophistication in an engraving again in his career. To Dürer's contemporaries, the significance of the print also lay in the interpretation of the subject. Melancholy was traditionally associated with illness, but it is here linked to the process of creative activity, represented by the tools of the artist's profession that surround the figure.

Melancholia
1514
Engraving
242 × 188 mm

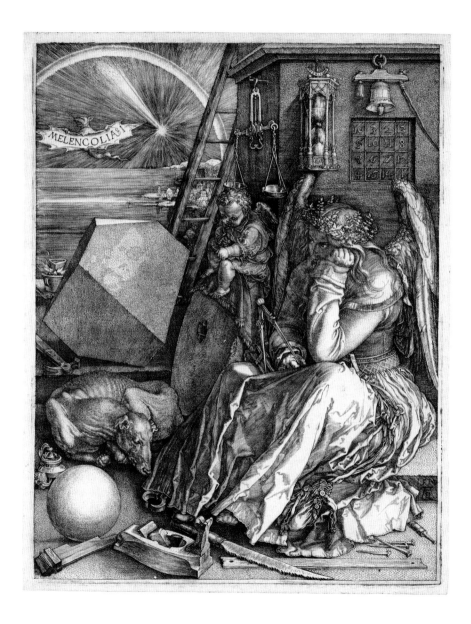

33 TWO STUDIES OF THE HEAD OF A CHILD

This sheet of studies of a child's head was made for the sleepy child genius, which represents inspiration, seated on the circular stone in *Melancholia* (no. 32). It is one of six drawings to have survived which Dürer made directly in preparation for that print.

Two Studies of the Head of a Child
1514
Pen and brown ink
273 × 172 mm

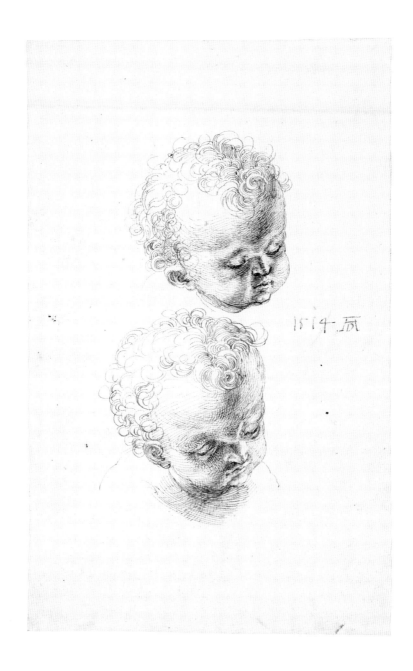

34 THE RHINOCEROS

35 THE RHINOCEROS

The inscription reads: 'On 1 May 1513 [1515] was brought from India to the great and powerful king Emanuel of Portugal at Lisbon a live animal called a rhinoceros. His form is here represented. It has the colour of a speckled tortoise and it is covered with thick scales. It is like an elephant in size, but lower on its legs and almost invulnerable. It has a strong sharp horn on its nose which it sharpens on stones. The stupid animal is the elephant's deadly enemy. The elephant is very frightened of it as, when they meet, it runs with its head down between its front legs and gores the stomach of the elephant and throttles it, and the elephant cannot fend it off. Because the animal is so well armed, there is nothing that the elephant can do to it. It is also said that the rhinoceros is fast, lively and cunning.'

Dürer's print of a rhinoceros caused a sensation. Several thousand impressions were produced during his lifetime and its popularity has endured over the centuries through the production of countless copies in a variety of media. The woodcut records the first appearance of a rhinoceros in Europe since the third century ad. The creature was presented as a gift from Sultan Muzafar II of Gujurat to the governor of Portuguese India, Alfonso d'Albuquerque, who sent it on to King Manuel I in Lisbon. After a few months it was despatched to Rome as a gift to the Pope, but died at sea after the ship transporting it to Italy capsized. Dürer never saw the animal himself. His preparatory drawing for the woodcut is an imaginative design of the rhinoceros based on a description and sketches sent from Lisbon to Nuremberg.

The Rhinoceros, 1515
Woodcut, 248 × 317 mm

Nach Christus gepurt.1513. Jar. Adi. 1. May. Hat man dem grofzmechtigen Kunig von Portugall Emanuell gen Lysabona pracht auß India/ein sollich lebendig Thier. Das nennen sie Rhinocerus. Das ist hye mit aller siner gestalt Abconderfet. Es hat ein farb wie ein gesprenckelte Schildkrot t. Und ist von dicken Schalen vberlegt fast fest. Und ist in der gröfz als der Helfandt Aber nydertrechtiger von paynen/vnd fast weerhafftig. Es hat ein scharff starck Horn vorn auff der nasen/ Das begyndt es alweg zu werzen wo es bey staynen ist. Das dosig Thier ist des Helfandts todt feynde. Der Helffandt furchts es fast vbel/dann wo es In ankumbt/so laufft Im das Thier mit dem kopff zwischen dye fordern payn/vnd reyst den Helffandt vnden am pauch auff vnd erwürgt In/des mag er sich nit erweren. Dann das Thier ist also gewapent/das Im der Helffandt nichts kan thun. Sie sagen auch das der Rhynocerus Schnell/ Fraydig vnd Listig sey.

1515

RHINOCERVS

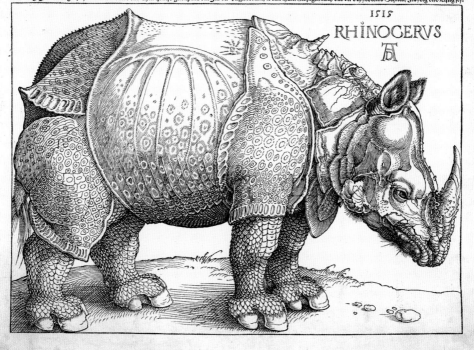

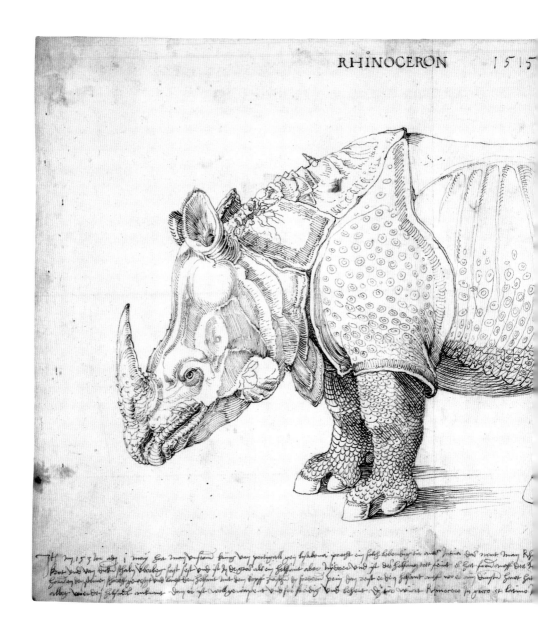

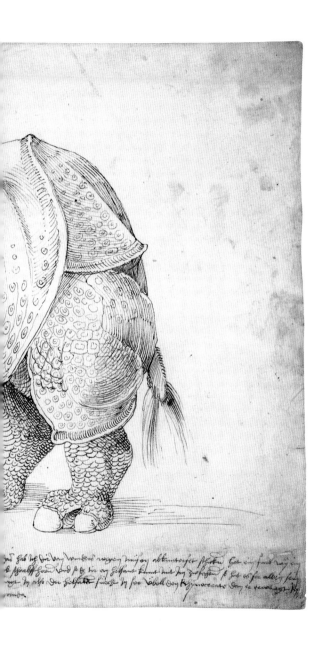

The Rhinoceros
1515
Pen and brown ink
274 × 420 mm

The most famous monumental print of the Renaissance period, Dürer's *Triumphal Arch*, was commissioned by the Holy Roman Emperor Maximilian. It was intended to be coloured by hand and used as a massive wall decoration, but examples of the complete set are extremely rare and only two examples of the first edition of 700 sets of the print have survived with contemporary colouring (Berlin and Prague). The inscription on the tablet under the dome above the central arch gives the title and dedication of the work: 'This Arch of Honour with its several portals is erected in praise of the most serene, all-powerful prince and sovereign Maximilian, Elected Roman Emperor and Head of Christendom in memory of his honourable reign, his gentility, generosity and triumphal conquests.' The programme was devised by Johann Stabius, who explains underneath that it was constructed after the model of 'the ancient triumphal arches of the Roman Emperors'. Above the central arch, entitled Honour and Might, is a genealogy of Maximilian in the form of a family tree. Above the left arch, Praise, and the right arch, Nobility, are represented events from his life. These are flanked by busts of emperors and kings on the left, and a column of Maximilian's ancestors on the right. The outermost towers on either side show scenes from the private life of Maximilian.

The Triumphal Arch
1515
Woodcut printed from 192 blocks
3570 × 2950 mm

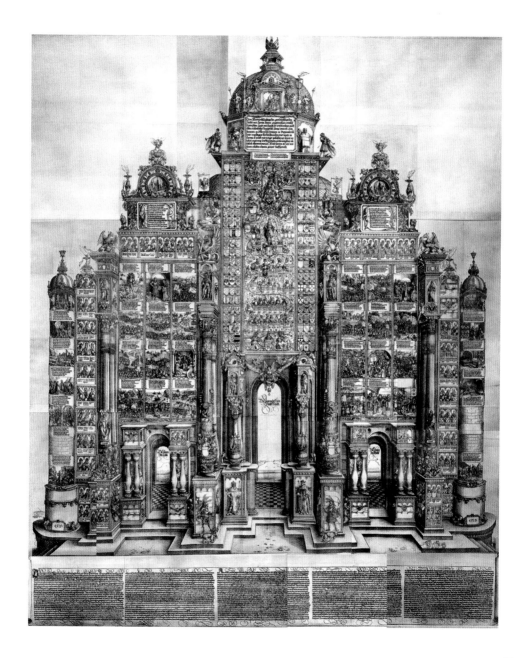

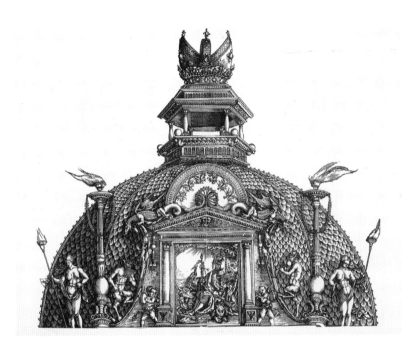

Detail of *The Triumphal Arch*

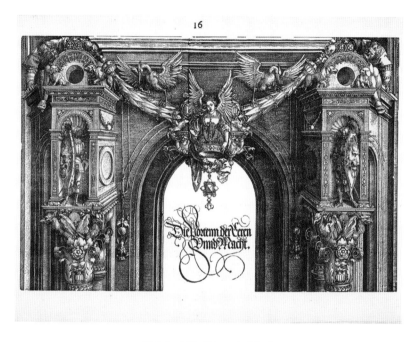

Detail of *The Triumphal Arch*

37 THREE ORIENTALS

38 LANDSCAPE WITH A CANNON

Dürer made just six etchings, all between 1515 and 1518. They have an experimental feel to them, perhaps because the technique had only been used for printmaking for about a decade. *Landscape with a Cannon* is famous for its extensive landscape. The cannon has the Nuremberg coat of arms on its tool-box and has been identified as an old-fashioned type made between 1450 and 1480. It has an air of abandonment about it. The figure of a Turk, standing enigmatically nearby, wears a costume based on a figure drawn by Dürer in *Three Orientals* more than twenty years earlier. He made this watercolour while he was in Venice from 1494 to 1495; it is a copy of three figures seen in the background of a large painting by Gentile Bellini (1429?–1507), *Corpus Christi Procession in Piazza San Marco* (Venice, Accademia).

Three Orientals
c.1494–5
Pen and black and brown ink, with watercolour
306 × 197 mm

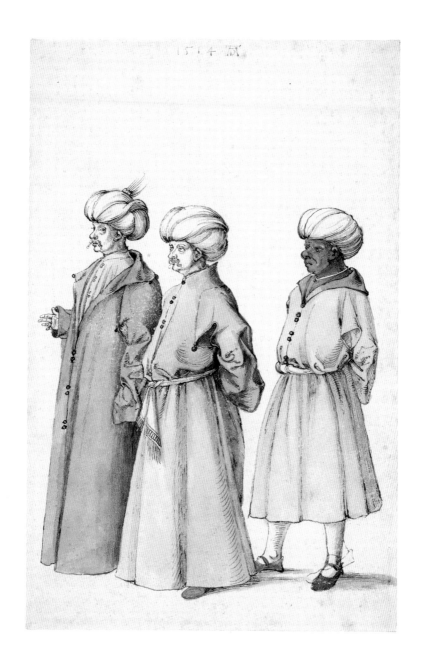

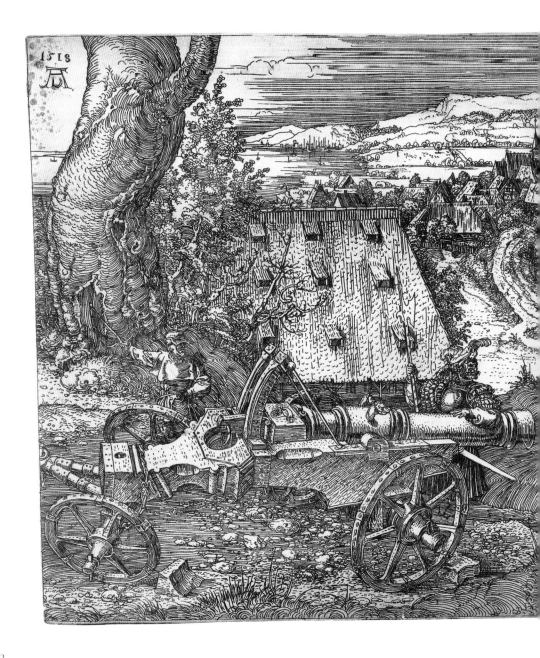

Landscape with a Cannon
1518
Etching
218 × 324 mm

39 ST CHRISTOPHER

40 ST CHRISTOPHER WITH HIS HEAD TURNED
 TO THE LEFT

41 ST CHRISTOPHER FACING RIGHT

The cult of St Christopher, the patron saint of travellers, was particularly strong between the thirteenth and the sixteenth centuries. This elaborately executed drawing was made approximately at the same time as the two prints, although not in preparation for them. It may be connected to a gift of four drawings of St Christopher 'on grey paper heightened with white' which Dürer records presenting to his friend, the landscape painter Joachim Patinir (c.1485–1524), whose wedding he attended in Antwerp in 1521.

St Christopher
*c.*1521
Pen and black ink, heightened with white,
on dark grey prepared paper
186 × 140 mm

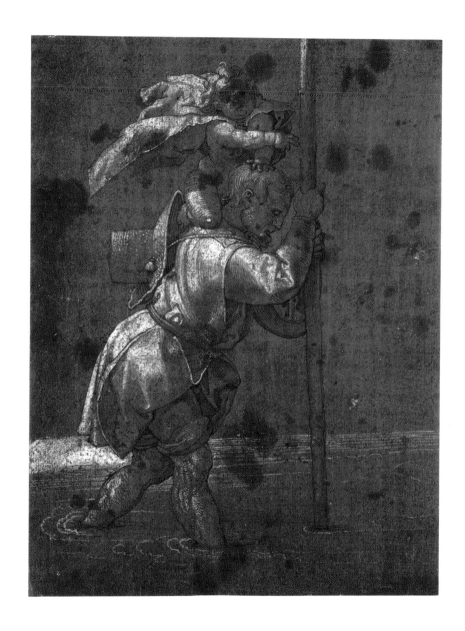

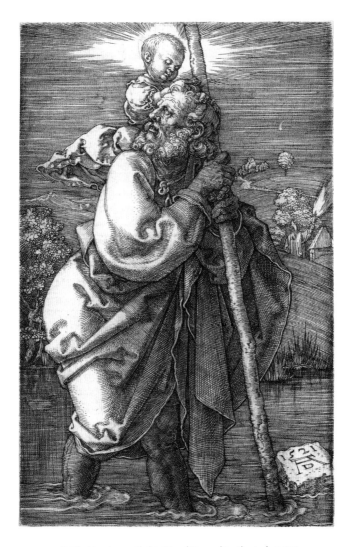

St Christopher with his Head Turned to the Left, 1521
Engraving, 117 × 76 mm

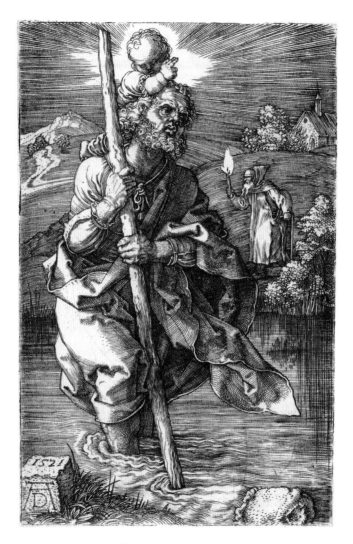

St Christopher Facing Right, 1521
Engraving, 117 × 76 mm

42 PORTRAIT OF A MAN, POSSIBLY BERNHARD VAN REESEN

Portrait drawings formed a substantial part of Dürer's output throughout his career, and particularly during his travels in the Netherlands, where he drew portraits on commission, as gifts for friends or in payment of bills. This drawing may represent Bernhard van Reesen (1491–1521), a merchant from Danzig who was in Antwerp during 1520–1, and whom Dürer records painting in oils in March 1521.

Portrait of a Man, possibly Bernhard van Reesen
1521
Charcoal
378 × 271 mm

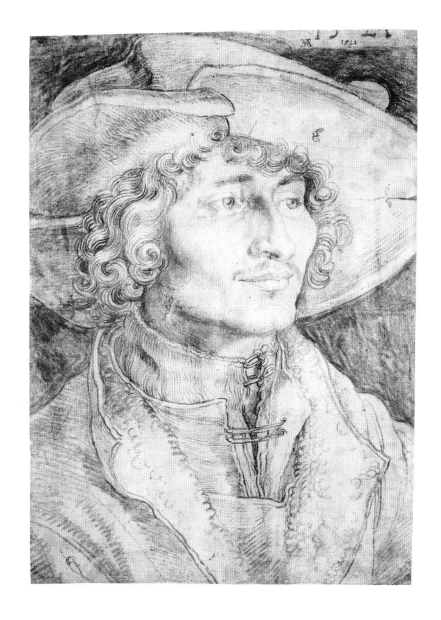

In contrast to his large output of portrait drawings, Dürer produced just eight portrait prints, only two of which are woodcuts, both of which he produced towards the end of his career. The design of this woodcut is identical to the formula he frequently used for his charcoal and black-chalk portraits: the head and shoulders of the sitter are shown against a dark background, with a blank space above for the inscription. Ulrich Varnbüler (1471–*c*.1544) was from 1507 chief clerk of the Imperial Supreme Court, of which he was made chancellor in 1531. To judge from the elaborate inscription on the scroll, he was well known to the artist: 'Albrecht Dürer of Nuremberg wishes to make known to posterity and to preserve by this likeness his singular friend, Ulrich surnamed Varnbüler, Chancellor of the Supreme Court of the Roman Empire and at the same time privately a distinguished scholar of language.'

Portrait of Ulrich Varnbüler
1522
Woodcut
434 × 325 mm

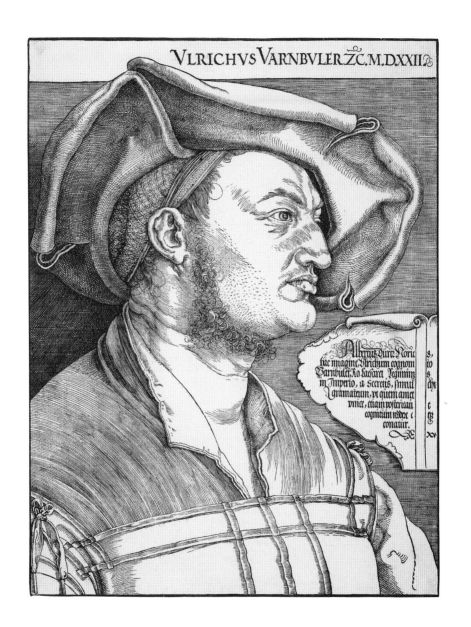

VLRICHVS VARNBVLER ℨC.M.D.XXII.

44 PORTRAIT OF DESIDERIUS ERASMUS

This is the last printed portrait that Dürer made, and is also the most elaborate. Dürer met the famous Dutch scholar Desiderius Erasmus (1467–1536), who was the first editor of the New Testament, three times in the Netherlands in 1520–1. On these occasions, Erasmus had given Dürer a Spanish '*mantilla*' and three portraits, and Dürer had presented Erasmus with a set of the *Engraved Passion* (see no. 28). Erasmus expressed his interest in obtaining a portrait from Dürer in correspondence with the artist's friend Willibald Pirckheimer in 1523 and 1525, but several months elapsed before Dürer produced it. Its formal appearance shows Dürer's respect for Erasmus as a man of letters. The Latin inscription reads 'Portrait of Erasmus of Rotterdam, drawn from life by Albrecht Dürer' and the Greek inscription underneath states that the writings of Erasmus will show a better portrait of the man than the print.

Portrait of Desiderius Erasmus
1526
Engraving
249 × 193 mm

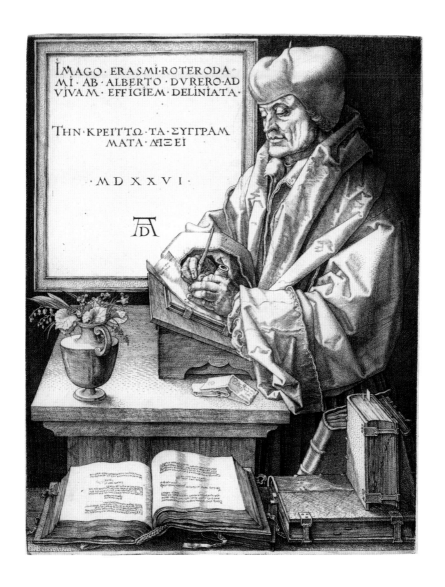

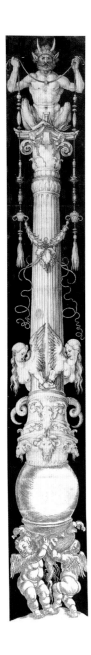

45 DESIGN FOR THE GREAT COLUMN

46 THE GREAT COLUMN

Dürer's lively interest in ornament of all types is evident in his drawings, but comparatively few prints of a decorative nature by him have survived. It is likely that he designed many more large prints for the decoration of interiors than are known from his surviving work. This elaborate drawing incorporates a classical column, bound harpies and playful putti and was designed for an interior painted in an Italian Renaissance style. Such decorative schemes were increasingly fashionable in early sixteenth-century Nuremberg. The woodcut version is based closely on the drawing, but was probably produced as a separate project to be sold to a widermarket at a cheaper price.

Design for the Great Column
1513–17
Brush and black and grey ink
with watercolour
1657 × 232 mm

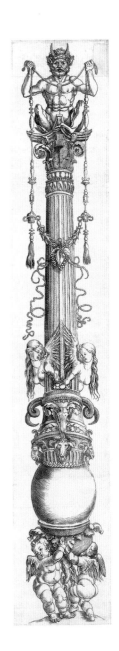

The Great Column
1513–17
Woodcut
1603 × 280 mm

FURTHER READING

The literature on Dürer is vast. This list is intended as a guide to books available in English.

BIOGRAPHIES AND GENERAL WORKS

D. Eichberger and C. Zika (eds), *Dürer and his culture*, Cambridge, 1998.

M.M. Heaton, *The History of the Life of Albrecht Dürer of Nürnberg: with a translation of his Letters and Journal, and some account of his Works*, London, 1870; facsimile reprint by Elibron Classics Ltd, 2005.

D. Hess and T. Eser (eds), *The Early Dürer*, exh. cat., Germanisches Nationalmuseum, Nurembury, 2012.

J.C. Hutchison, *Albrecht Dürer: A Biography*, Princeton, 1990.

J.L. Koerner, *The Moment of Self-Portraiture in German Renaissance Art*, Chicago, 1993.

E. Panofsky, *The Life and Art of Albrecht Dürer*, with an introduction by J. Chipps Smith, Princeton Classic Editions, 2005.

N. Wolf, *Albrecht Dürer*, Cologne, 2006.

PRINTS AND DRAWINGS

G. Bartrum, with contributions by G. Grass, J.L. Koerner and U. Kuhlemann, *Albrecht Dürer and his Legacy: The Graphic Work of a Renaissance Artist*, exh. cat., British Museum, London, 2002.

S. Buck and S. Porras (eds), *The Young Dürer: drawing the figure*, exh. cat., Courtauld Institute Galleries, London, 2013.

W. Kurth, *Albrecht Dürer: The Complete Woodcuts*, Mineola, NY, 1963.

C. Müller *et al.*, *From Schongauer to Holbein: Master Drawings from Basel and Berlin*, exh. cat., National Gallery of Art, Washington, 1999.

A Robison and K.A. Schröder, *Albrecht Dürer: Master Drawings, Watercolours and Prints from the Albertina*, exh. cat., National Gallery of Art, Washington, 2013.

J. Rowlands, with the assistance of G. Bartrum, *Drawings by German Artists and Artists from German-speaking Regions of Europe in the Department of Prints and Drawings in the British Museum: The Fifteenth Century, and the Sixteenth Century by Artists born before 1530* (2 vols), London, 1993.

W.L. Strauss, *The Complete Drawings of Albrecht Dürer* (6 vols), New York, 1974.

W.L. Strauss (ed.), *The Complete Engravings, Etchings and Drypoints by Albrecht Dürer*, Mineola, NY, 1972.

I. Zdanowicz (ed.), *Albrecht Dürer in the Collection of the National Gallery of Victoria*, exh. cat., Melbourne, 1994.

ILLUSTRATION REFERENCES

page

2 © Museo Nacional del Prado, Madrid; inv. P2179

9 PD 1910,0212.310 (Bequeathed by George Salting)

10 PD 1928,1013.1 (Presented by subscribers through the National Art Collections Fund)

13 PD 1983,0416.2 recto

15 PD 1973,U.166 (Bequeathed by the Revd C.M. Cracherode, 1799)

17 PD SL,5218.98

19 PD 1868,0822.192 (Bequeathed by Felix Slade)

21 PD SL,5218.172

23 PD 1895,0122.600 (Presented by William Mitchell)

25 PD SL,5218.173

26 PD 1868,0822.170 (Bequeathed by Felix Slade)

28–9 PD SL,5218.166

30–1 PD SL,5218.167

32 PD E,4.111 (Bequeathed by the Revd C.M. Cracherode, 1799)

33 © The National Gallery, London; inv. 6563. Purchased with the assistance of the Heritage Lottery Fund, the National Art Collections Fund and Sir Paul Getty Jr through the American Friends of the National Gallery, 1996

35 PD SL,5218.165

37 PD E,4.68 (Bequeathed by the Revd C.M. Cracherode, 1799)

39 PD 1895,0122.629 (Presented by William Mitchell)

41 PD 1846,0918.9

43 PD 1895,0915.346

45 PD SL,5218.114

47 PD 1895,0915.973

49 PD 1895,0122.627 (Presented by William Mitchell)

51 PD 1868,0822.167 (Bequeathed by Felix Slade)

page

52 PD SL,5218.181

53 PD SL,5218.182

54–5 PD SL,5218.157

57 PD SL,5218.29

59 PD 1895,0122.618 (Presented by William Mitchell)

61 © The J. Paul Getty Museum, Los Angeles; inv. 83.GA.360

63 PD E,2.53 (Bequeathed by Joseph Nollekens (1737–1823) subject to a life interest to Francis Douce, 1834)

65 PD E,4.109

66 PD 1868,0822.198 (Bequeathed by Felix Slade)

67 PD 1960,1008.2

69 PD 1895,0915.345

71 PD SL,5218.39

73 PD 1895,0122.714 (Presented by William Mitchell)

74–5 PD SL,5218.161

77–9 PD E,5.1 (Bequeathed by Joseph Nollekens (1737–1823) subject to a life interest to Francis Douce, 1834)

81 PD 1895,0915.974

82–3 PD 1910,0212.308 (Bequeathed by George Salting)

85 PD SL,5218.178

86 PD E,4.103 (Bequeathed by the Revd C.M. Cracherode, 1799)

87 PD E,4.104 (Bequeathed by the Revd C.M. Cracherode, 1799)

89 PD SL,5218.54

91 PD 1895,0122.739 (Presented by William Mitchell)

93 PD 1868,0822.202 (Bequeathed by Felix Slade)

94 (Left) PD SL,5218.87-89
(Right) PD E,2.405 (Bequeathed by Joseph Nollekens (1737–1823) subject to a life interest to Francis Douce, 1834)